'This book is at once penetrating and kaleidoscopic, full of exposition coupled with evocative ethnographic illustration. It extends Gell's ideas into new domains... The synthesis is extraordinary. Ranging across time and space and diversity of perspectives compared and contrasted, this volume will take its place alongside others—one thinks of *The Savage Mind, Purity and Danger*.'
— **Frederick H. Damon**, *University of Virginia, USA*

'Küchler and Carroll have brought their different anthropological experiences and deep knowledge together in a book to engage the anthropology of art with a deep reading and extension of Alfred Gell's framework. Calling for a "return to the object," a theoretical project that follows Gell's movement away from the emphasis on signification and to the study of "relations immanent within objects", the book is ethnographically detailed and philosophically articule. Readers may find it a challenging formulation, spanning over numerous case studies, but it rewards us in profoundly enriching the possibilities of the anthropology of art.'
— **Fred Myers**, *New York University, USA*

'Vivid, generous, and theoretically exciting, Küchler and Carroll bring the Anthropology of Art back to the world of big ideas. But never at the expense of the objects themselves. Featuring an extraordinary array of ethnographic detail and insight, this landmark publication is a must-read for anyone seeking to become more alive to the generative, relational, and conceptual capacities of images and objects. The work of apprehension it argues for—and offers up—is astonishing.'
— **Jennifer Deger**, *James Cook University, Australia*

A RETURN TO THE OBJECT

Alfred Gell, Art, and Social Theory

Susanne Küchler and Timothy Carroll

LONDON AND NEW YORK

28 Rethinking the frame

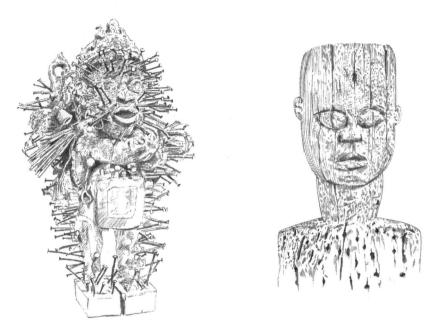

FIGURE 1.2 An original line drawing showing a side-by-side comparison of the *'nkisi*, which appeared in Carl Einstein's *African Sculpture*, stripped of its nails (right), and a 19th century *'nkisi* figure from Kongo (left), composed of wood, natural fibres, and nails; part of the Christina N. and Swan J. Turnblad Memorial Fund, 71.3, Minneapolis Institute of Arts. A similar layout was used by Einstein.

one and become the figure carved from the tree. In carving the figure, the priest also affixes to the chest a broken piece of mirror. Once made, the *'nkisi* is a knot of partial relations of the community. Anyone can invoke the aid of the *'nkisi*, making an oath before the figure and driving a nail into its body. In standing in front of the figure, the oath-making individual sees not only the composite of tree, chicken, and strong hunter, but also a partial reflection of their own self as part of the figure. These oaths are provoked by community disputes, and may either be a plea of innocence or a cry for vengeance.

In driving a nail into the figure, the individual does not simply call to mind the contested relations that are known within the village. Each nail is not a substitutional representation of conflict. Rather, it captures the futurity of relations reworked via the capacity of the *'nkisi*. The accumulation of nails driven into the figure further develops the complexity of relations that come to be manifest in the figure. The growth of the *'nkisi* enacts the invisible desire of the oath-maker. The attribution of judicial capacity to the *'nkisi* figure, which is said to kill the person named as the nail is driven into the wooden frame of the figure, shows a logical sequence of alternating passive and active relations that allows *'nkisi* to manifest the operative quality of a cumulative agency of which it is itself a part.

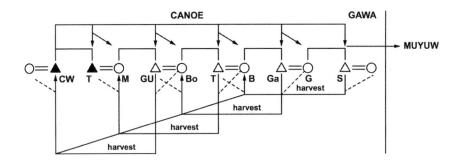

▲ = canoe-building dala
S.G = siblings (1 mother)
Ga. B = siblings (1 mother)
T. Bo = mother's brother- sister's child different dala of kumila
Gu. M = siblings (1 mother)

FIGURE 2.1 The diagram of kinship and trade circulation, after 'Figure 4. Canoe paths' in Nancy Munn (1986, 133).

received by affines, thus strengthening internal affinal relations. Like named *kula* shells, canoes and their paths are remembered as sequences of individual names that recall the onward sequence of their transmission.

As a sign of the shift from female- to male-centred exchange and from stasis to motion, the food that is given by the wife's or affinal matriclan to the builder and/or owner of the canoe is taken from the tops of trees, rather than from gardens. Men scrape the coconut and mix it with the boiled taro prepared by women into a pudding, which is cooked by the men in large clay cooking pots that are stirred vigorously while standing. The taro pudding produced by men in this way is accompanied by the slaughter of pigs that, like all mobile and thus masculine elements, are known by names. Over time, as the canoe is transmitted from one owner to the next, return gifts flow in a multiplicative manner back to the original canoe builder along the canoe's path. The return gifts are public events of inter-hamlet processions marked by vivid expressions of vitality and of the spatiotemporal analogue of movement as the processions forms linear passage that traces the canoe's journey connecting hamlets and islands with one another. The canoe's path thus connects and extends affinal relations that span hamlets, villages, and islands, moving as it does as a gift from the male side, and transacted in relation to *kula* shells. Within Gawa, the canoe and *kula* shells go in the same direction, as they are both marital gifts from the man's kin; when the canoe is transacted to the southerly islands, it is moving against armshells and pots that are moving north. Armshells and pots eventually reach the canoe builder as a return gift by the overseas recipient on his journey north.

The sequence by which returns are made is attended to closely, although in actual fact they rarely happen as described. It is a common understanding that what should happen is that the initial recipient of the overseas returns is the last Gawan

events in 'dreamtime', with each bark painting referencing at least five such place markers via graphic signs that are themselves distinguished into outer and inner, public or secret, with the understanding that the most secret signs will not be made visible to non-initiated men and women (Morphy 1989). The distinction between background and foreground is effaced through an overlay of 'cross-hatching' lines that form geometric motives, the formal quality of which is recognized as mapping biographical relations, allowing bark paintings to convey information about kinship alongside place information.

Morphy (2007) discusses the transformational effect of cross-hatching whose shimmering (*bir'yun*) is the result of painting lines in red, white, yellow, and black over red ochre and yellow and black outlines of graphic elements. The interplay of graphic elements between foreground and background allows paintings within paintings to emerge in a generative kind of fashion illustrative of the ancestral power bark painting is thought to make manifest and to exude in its most potent, secret form (82). Cross-hatching as a technique lends itself to complex and multi-dimensional images that appear simultaneously above and below the surface, by redefining them at different stages of the process. Painting as capturing a process of 'becoming' is evidenced in the fact that while it is tempting to trace an association between geometric motifs created through cross-hatching and clan

FIGURE 3.2 A line drawing of an Aboriginal Australian hollow log coffin, detailing the cross-hatching design, after the object with accession number M.0079 in UCL's Ethnographic Collections.

64 Rethinking the frame

painter uses the five-circle grid, modifying it to reference particular sites that play particular roles in the ritual sequences of initiation, while using it again and again (228). Different paintings thus travel around different sites and map the unfolding of distinct ancestral events, while drawing them together via the same underlying circular grid. The perspective of the unfolding sequence, rather than following the linear motion of the ancestor's journey narrated in the story, is de-centred while simultaneously enabling the illusion of an egocentric, relative, and transitive viewpoint while holding stable multiple perspectives on one and the same place. The five-circle grid thus contains within itself the possibility of extension via circles and lines to other places and other stories. These extensions in turn become the focal point for new grids so that eventually a network of relationships between sites, stories, and grids is created (233).

The multiplicity and magnitude of aggregation of circles in relation to one another are the consistent themes running through Myers's analysis of Tjakamarra's work to which are added rectilinear forms and path motives that appear around the same time as a major initiation ceremony takes place in the painter's ritual group. Large canvases that started to be used after the recording of the sequence of images led to the replication of motifs and their extension to other sites and in combination with dreamings from different places. In short, the complexity of paintings increased while the underlying grid structure remained the same. In comparison with Tjakamarra, Wuta Wuta's early paintings are less concerned with a virtuosic

Painting 20. *Wilkinkarra.*

Painting 48. *Wilkinkarra.*

Painting 62. *Kanaputa.*

Painting 115. *Yukurpanya*

Painting 163. *Wilkinkarra.*

FIGURE 3.3 A selection of the Wilkinkarra Series, after the sample provided by Fred Myers (2002, 110) in *Painting Culture.*

78 Rethinking the frame

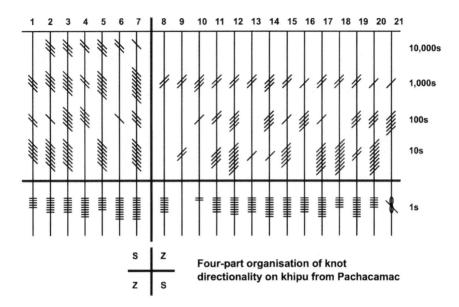

FIGURE 4.1 Diagram showing quadrants of the Khipu from Pachacamac, after Gary Urton's (2003) 'Figure 3.14 Four-part organization of knot directionality on khipu from Pachacamac' (87).

complement (2, 4, 6, . . .) to form complete number sets (Urton 2003, 89–90). Quechua numerical ontology also informed the organizing principle of decimal values registered in the *khipu* (Urton 1997; 2003, 90). To register such decimal values, three major sign types are used: figure-eight knots indicating ones (single units); long knots, signifying units from 2 to 9; and single knots, which, depending on their position on the string, signify any one of the full decimal units (10; 100s; 1,000s; or 10,000s). In line with the ordering principles of Quechua numeration, every knot is both an individual binary coded signifying unit and a component of a sum that could have been of administrative, calendrical, or even purely mathematical value for state record keepers.

In the first order, the *khipu* as records are a type of substitutionary representation; however, the importance of the string, and its capacity to model via its affordances to be manipulated into different types of cordage and knots, as well as colour, means that the prototypical information after which it is modelled is held in the artefact, not distanced from it. The prototypical information immanent in the *khipu* is the relational quality of sequences of numbers that are paradigmatic to the cosmological understanding of relations and principles of ordering. In this case, unlike with the introduction of limewood alongside the advent of new sociability, here the artificiality of the knotted cords reaffirmed the 'paradigm certainty' formative of the Inka state up until the moment of colonial intrusion.

Where the *khipu* can be seen to draw distributed data together in bundles of information via an algebraic system of numbers and rules expressed in the

80 Rethinking the frame

FIGURE 4.2 Malanggan funerary figure. Drawing after a figure collected by Alfred Bühler held in the Basel Museum of Cultures.

Fixing what is an apparently bewildering multiplicity of potential biographical relations into a dyadic pattern of genealogical relations, eastern Polynesian piecework coverlets hold in place biographies that are already completed before they begin. Known in Tahiti as *tifaifai* and the Cook Islands as *tivaivai*, coverlets are composed of iteratively assembled self-similar geometric or figurative, usually floral, patterns that are themselves assembled from self-similar, iteratively arranged geometric pieces (Küchler and Eimke 2009). While seemingly two dimensional and flat, the construction of the piecework coverlets is informed by a relational numerical ontology not too dissimilar to the ideas informing the Andean *khipu*. Historically, Cook Islanders did, in fact, also have a complex system of knotted cordage covering iteratively carved longshafts. At the advent of colonial Christianity, the male practice of ritual tying and untying of these carved figures was forbidden, and the practice ceased. However, in its absence, the women, who were taught stitching and sewing by the missionary wives, took up the same modelling in the new material of ready-coloured cloth and its potential to be sewn into ever-changing and yet diagrammatically 'correct' patterns (Küchler 2017). In the Cook Islands, where piecework making dominates the lives of women and the exchanges of a household, encode foreign and home-born ancestors, and it is the relation between the two that defines every individual in every generation, over and over again. Wrapped as shrouds around the dead, *tivaivai* are lowered into tombs, the superstructures of which resemble the houses that dot each of the islands on which *tivaivai* frame the lives of the inhabitants. The geometric patterns visible on the surface of the piecework coverlets form assemblages much

Virtuosity and style **95**

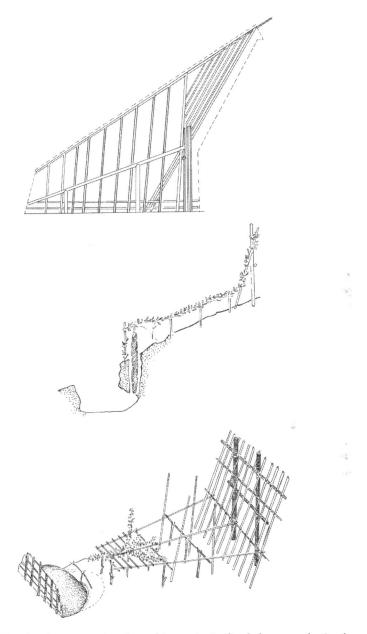

FIGURE 5.1 Line drawing comparing the architectonic similitude between the Sepik initiation house and the yam trellis, after 'Figure 16. Seitenriß des korambo der nordwestlichen Abelam, Wewungge, Kuminimbis' in *Kulthäuser in Nordneuguinea* by Brigitta Hauser-Schäublin (1989a, 92) and field sketches provided to us by Ludovic Coupaye.

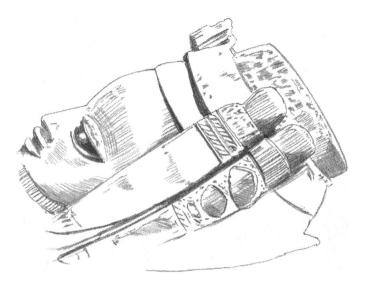

FIGURE 6.1 Yoruba *Gelede* headdress, after Figure 14.7 of Robert Farris Thompson ([1973] 2006, 266).

Taken in this light, the question about how art works and what it 'does' hits on the sticking point of Gell's critique of aesthetics, as formulated in his early article on technology of 'enchantment' (1988, 1992b) and in the work produced later in response to Jeremy Coote (1992; Gell 1995b) and Howard Morphy (1992; Gell 1998). Contrary to the common misreading of *Art and Agency* (see, for example, the contributions in the volume *Beyond Aesthetics* edited by Pinney and Thomas 2001), aesthetics is an essential aspect to the abductive work that holds the nexus together. It is via aesthetics that one is able to contemplate the nature of relation, moving from the object outward along abductive strings of association (cf. Bateson 1979). While Gell overtly rejects aesthetics, he does so not because of what it is as an analytical practice, but because of its intellectual baggage, being mired in the project of European philosophy. The prejudice of thought seen in the aesthetisation of ethnographic art was anathema to Gell's sense of methodological philistinism. His first confrontation with the issue of aesthetics, the essay on technology of enchantment (published 1992b but written in 1985) was provoked by the publication of the catalogue of a paradigm-shifting show at the Museum of Modern Art that documented the influence of 'primitive art' on modernism (Rubin 1984). This show marked the end of the colonial project and the rising independence of the countries of origin. The aesthetisation of ethnographic collections, seen also in the establishment of the Hall of Masters in the Louvre, rapidly became a contested method used for exhibiting indigenous artefacts sterilised from their social, political, and historical contexts of production, use, and acquisition. In avoiding the term aesthetics in *Art and Agency*, he focuses on style and virtuosity as compelling the work of abduction. This is, to our reading, not a denial of aesthetics (in its original sense), but rather

Spring-hook fish trap

Spring-basket fish trap

FIGURE 6.2 After Captain JG Stedman's sketches of 'Manner of catching Fish by the Spring-Hook' and 'Manner of catching Fish by the Spring-Basket', in his *Narrative, of a five years' expedition against the Revolted Negroes of Surinam, in Guiana, on the Wild Coast of South America* (1813, 236–237; cf. Gell 1996, Figure 11).

grid produced of the bricks lined up alongside and atop each other. Choosing fire bricks,[1] sourced from the coal-mining towns of his youth, rather than commercial building bricks, the bricks were also themselves devoid of the decorative stamp of the maker's mark. In a manner, typical of the 'systemic' or 'ABC' art movement he

1 Different bricks were used for the original (1966) and the reproductions (1969); for more, see Ronald Alley (1981, 11–12).

Generativity and transformation 125

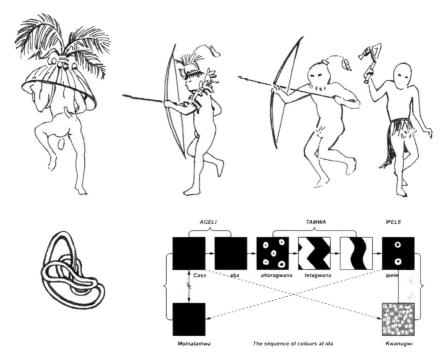

FIGURE 7.1 Line drawing of design of *ida* dancers used in the *ida* festival alongside the path traced in the clearing by the dancers, and the colour diagrammatic, showing move from black to red, after 'Figure 42 The transformation of mask-types' and 'Figure 46 The sequence of colours at *ida*' in Alfred Gell (1975, 299, 322–323).

(fish) in all red, leading eventually to the *ipele* (bowman) in red and black designs – Gell frames the passion of the *ida* to be as much about the colour dynamics as the symbolic exegesis of the animals. In fact, he argues that the man is not painted black to represent the cassowary, so much as the man is painted like a cassowary to be black. In this sense, the sequentiality of the *ida* comes to the fore as a passion play of alternating black and red, which, as Gell demonstrates in the wider social context, is identical to the dynamism of generationality, for example that played out between a mother's brother and a sister's son.

Person as artefactual

Elsewhere in the Melanesian context, Marilyn Strathern (1988, 1996) has established that composite and multi-authored relations immanent within persons are made manifest externally only partially and fleetingly as they are given form in objects. Objects in fact, Strathern argues, are the outcome of processes of decomposition, by which persons, constituted as multiple and partible, come to be singular for moments at a time. Forms thus achieve social effects as they instantiate

many times as there are layers of differently coloured fabric while still allowing the patterns to emerge clearly. Women keep a stockpile of multi-coloured fabric leftovers to fill little spaces within designs and to make decorative motifs that are superimposed on the composite patterns. To understand the *mola* and the complex associations it evokes, relating fertility, the human life cycle, and everyday experiences, we thus need to bear in mind the overriding significance of an invisible, immaterial reality, underlying and intimately linked to the visible, material world (Margiotti 2013, 394–395).

The idea of the counterpart of the visible world in another invisible one underpins the understanding of conception, pregnancy, and birth in ways that foregrounds the mediatory role of design. Paolo Fortis (2010) shows design to be aligned to the amniotic sac, which bridges the two worlds and leaves an imprint on persons in the form of designs imprinted on the forehead at birth. Designs, emerging during gestation, are the gateway to the invisible counterpart of persons, and this is as relevant to the shamanic carvings of the Kuna as to Kuna women's stitched blouses. In fact, the multi-layering of the *mola* corresponds to the multiplicity of counterparts women have in the invisible, compared to the singular counterpart of Kuna men. Fortis (2012) captures the intrinsic relation between shamanism and art among the Kuna, where shaman or *nelekana* are born with the white remains of amniotic designs on their head that predispose them to vivid dreams during childhood. He describes the birth and childhood of *nelekana*, whose affinity with design, known as *kurkin* (meaning the amniotic sack, the caul, as well as brain, intelligence, skill, hat, and headdress) predisposes them to have access to relationships

FIGURE 7.2 Line drawing of a *mola* design.

134 Following the prototype

defending the work of Richard Mutt (and indeed that of Duchamp in creating the gesture of *Richard Mutt, artist* [1917]) was, in many ways, entirely unremarkable (and unremarked). Certainly, these creative acts pale in comparison with the readymades of Duchamp, the 'found art' of von Freytag-Loringhoven, or indeed the literary and translation work of Louise Norton (better known by her subsequent name, Louise Varèse). Lost to the margins of the interartefactual project of art, *Fountain* in all its guises, exists as a case study today principally because of André Breton (and the singular photograph of Alfred Stieglitz). In his work, *Duchamp's Fountain (1917)*, Breton (1935) draws attention to a conceptual piece of rubbish, pulls it from the dumpster, and moves the valueless absence into the enduring icon of modernism that we know today.

This chapter explores the dynamic social potential of transformation. In thinking about how one thing can be made into another, and the associated creation (or destruction, or translation) of value, we are highlighting the ways in which this movement of value affect society at each intersection. In this way, the inherent socialness of art as action is brought to the fore. In thinking through the sociality of art, the chapter unpacks the notion of agency, considering how objects and material gestures are able to impact the art of social forms, not simply as conduits of meaning but generative of operative intersubjective sociality. First, we address the ideas of agency as intention versus as it is abducted, then we consider some theoretical interventions into the understanding of value transformation, and then we examine a series of case studies arising from both formal art contexts and wider social practice.

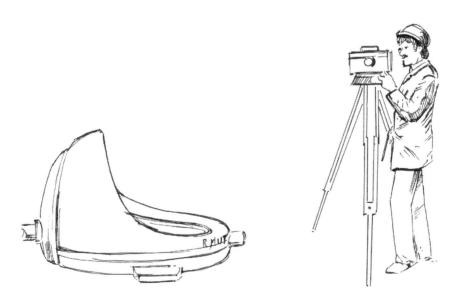

FIGURE 8.1 A dramatized rendering of Alfred Stieglitz photographing the *Fountain* by R. Mutt, 1917.

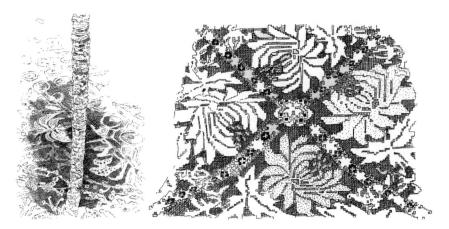

FIGURE 9.1 An example of a patterned *tivaivai* and the colour squares strung on a string, ready for assembly, after photos by Susanne Küchler.

being stitched into iteratively replicated and transitively arranged motivic elements to form a patchwork. Gifted during life, coverlets, wrapped around the dead and lowered into a tomb-like grave in a manner, underscore the unity of the dead and the living and the sense of the indivisible encompassing multiplicity manifest in the stitching of patchwork. The making of coverlets as shrouds for the dead started with the arrival of Chinese traders in Hawaii in late 1700 and moved from there alongside other ideas and practices, such as Christianity, to Tahiti and the Cook Islands. In the Cook Islands, woven cloth is still acquired from China, and the type of cloth that is preferred is course and roughly woven (Küchler and Eimke 2009).

Every island in the Cooks has its cloth store, multi-coloured threads for embroidery of applique coverlets and reams of different colours of cloth that is, and this may strike one as counter-intuitive, not colour-fast.[2] When purchasing cloth for the fabrication of a patchwork coverlet, women complain that cloth is no longer as good as it was in the 1970s when they started out as young women making patchwork coverlets. Then it had been so roughly woven that it could be ripped into thin strips that in turn could be cut into shapes and resewn into motives containing a greater number of coloured pieces than is possible today. But, at least, a sigh will follow, the cloth is still coloured. The idea that colour is actively worked into the cloth and thus should also come out again when washed, highlights a concern

2 As an interesting comparative aside, it is noteworthy that, similarly to the imported cloth seen here in the Cook Islands example, the Yap stones are fashioned from stone imported from distant islands (Furness 1910). While the stone money is so heavy as to be immobile, it is important to their capacity as credit-moving objects that movement is inherent in the exotic 'foreign' nature of the material on the island of Yap. Exactly the same case could be made for the heavy, almost immobile and ultimately sedentary coverlets, whose material is associated with the arrival of foreign trade, and the design is indicative of genealogical mobility.

166 Rediscovering the object

The other effect of frankincense, that is analogical instead of symbolic, is achieved through its transformation by burning, which thereby makes visible the invisible. Andrew Gould (2014), an expert in Byzantine liturgical arts, highlights the fact that incense is an architectural feature of the Byzantine temple. As the liturgical arts of the built environment developed, the importance of how light played within the temple was crucial. Each Orthodox temple is an icon of the universe, and particularly within monumental churches like Hagia Sophia in Constantinople, the placement of small windows circling the underside of the principle dome means that shafts of light shot down from the 'dome of heaven'. In Byzantine architectural practice, clay urns were set into the walls of many church buildings (Zakinthinos and Skarlatos 2007). These hollow cavities produce resonances, such that when the walls are met with sustained musical frequency, they (that is, the walls) begin to resonate. In such an environment, as the incense moves heavenward and catches the

FIGURE 9.2 The light and incense smoke playing with each other within an Eastern Orthodox cathedral.

Colour, palette, and gestalt 171

FIGURE 10.1 A close-up of painted beadwork, after an example from Louise Hamby and Diana Young (2001).

As she says, 'The capacity of a sacred site to become animated in this way, to become brightly coloured for a few minutes, appearing spatially expanded, highly visible and then invisible, confirms its Ancestral eminence' (367). While 'pink' is a foreign concept, with no link to the Ancestral beings that formed the landscape of Australia, red ochre (*karku*) is native, and deeply connected within the palette of ancestral dreaming. As such, when seeing the underside of a cockatoo, the grandmother sees a flash, or even a shimmer (cf. Morphy 1989, see Chapter 4), of the ancestral, while the granddaughter sees only 'pink'.

In her theoretical work on colour, informed by her ethnography in Aboriginal Australia, Young (2006) has argued that 'colour is a crucial but little analysed part of understanding how material things can constitute social relations' (173). Colours

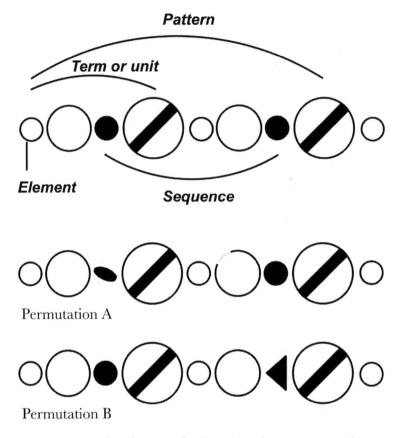

FIGURE 11.1 Pattern, and its elements, after Figure 4, and permutations and degradations of the pattern, after Figures 15 and 16 from Alastair Clarke (2008, 21, 30).

and we contend sociality more broadly, is contingent on the 'pattern fidelity', as the 'more accurate the repetition, the more exact the pattern' (29), the greater the impact of the inversion as comedy or the invention as continuity. However, as Wagner (1975) points out with the success of each invention, it rests in the dialectic between the controlling context of the immediate situation and the implicit context of the socio-cultural milieu. In this way, to run with Clarke's example, the joke will only work if its fidelity to the pattern is faithful to the knowledge of both contexts and can invert the one in line with the pattern fidelity of the other. Humour is not arbitrary unsettling of pattern, it is the disquieting of the anticipation of pattern according to the pattern of a higher order; it, like art more broadly, is a game played in the navigation between pattern and meta-pattern. If, as we have said, the distance between any pair is unresolved until its third comes into place, and this third both articulates the nature of the distance between 1 and 2, and becomes a pair to the first set, inviting yet another to articulate the continuation of sequence and close the pattern, then the relation between motivic elements is also motivation

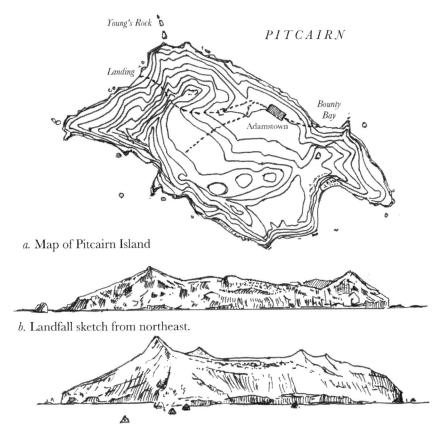

FIGURE 11.2 A map of Pitcairn, a landfall image, and one proposed by Alfred Gell, after Figure 2 of Gell's 'How to Read a Map' (1985, 281).

landfall image is sketched from position 'X' in the map (Figure 10.2a). Having the map, however, one is able to imagine the appearance of landfall from the opposite side (Figure 10.2c). As Deleuze argues in his discussion of Leibniz's insights on 'point of view as jurisprudence or the art of judgement', indicative images operate as anamorphosis, where the subject is left with chaos when outside the deictic position of perceptual verification (Deleuze 1993, 21f). The non-token-indexical beliefs, however, allow the subject to creatively imagine the elements along the path between A and B, verifying progress by the sequential perception of each landmark or stage as anamorphosis.

It is in this sense that knowing a pattern will allow navigation of new terrain. In the use of *matang* and the navigation in reference to an (unseen) *etak* (meaning 'refuge') island (Gell 1985, 284), the sailors navigate the voyage between two islands in reference to a third island. While this *etak* may be below the horizon, its position is rendered in reference to the movement of the stars, rising and setting

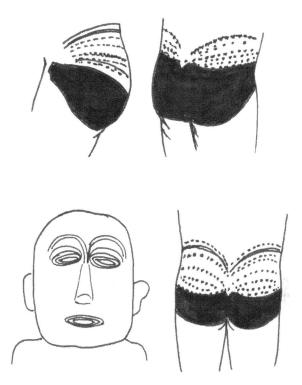

FIGURE 12.1 The face of a god, 'Oro, tattooed on the posterior of a Tahitian, after Alfred Gell's interpretation of Sydney Parkinson's eye-witness sketches from the Cook expedition in 1769.

posterior, then, made the human into a similarly oriented Janiform figure. This brought closer – as it made the dark unknown backside into a front side – and tamed the potent danger of the *po* into the abstracted but knowable face of god.

In this manner, the face tattooed upon the butt closes the open (and thus dangerous) pattern of the god-child in a way that opens up into possibility a whole range of subsequent actions. The danger of having a god present restricts actions – such that even the parents cannot eat before the first desacralization ceremony. However, upon completing the sequence of desacralization, the title-holding individual is made sufficiently *noa* that they can enter into mundane relations and pursue, for example trade with European men. The tattoo, and like it the wider artefactual patternation, is, therefore, primarily about the future, not the past or even the present. It is, subsequently, not a vehicle for remembering or for information transfer, but rather the movement of life forward into its next form.

The question of movement and form brings us back to the question of aesthetics. If, taking Kant's point about aesthetics as 'purposive without purpose' as a starting point, the function of the artefact (as a technical object or tool) is separate from its aesthetic functioning as an item that, as Simmel would describe it, was

216 Rediscovering the object

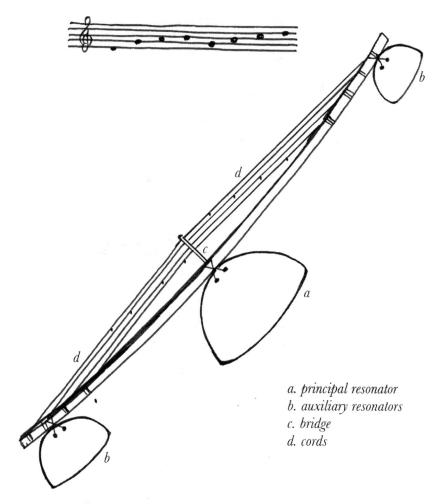

FIGURE 12.2 A diagram of the Fang *mvet* (harp), showing right and left sides, and the musical notes achieved with each string, after 'Figure 1 The Fang harp', from Boyer (1988) in 'Authorless authority' by Carlo Severi (2016, 138).

Gell's insight into the social agency mediated in and about an object is deeply situated in the Melanesian and Polynesian cosmologies through which he formed and articulated much of his insight. In this light, it is worth considering the relation between agency and patiency as akin to the duality of *ao* and *po*.[6] This is not

6 It is worth noting an almost certainly accidental parallelism between the two dualities. The shared initials (agency and *ao*, patience and *po*) are complimented by Gell's use of the arrow (→) to connote the relational movement from the 'a' to the 'p' in both. Agency → patient in *Art and Agency* (1998), particularly in the contexts of hierarchically ensconced shells of involution, and *ao* → *po* in *Wrapping in Images* (1993, 133). While it is unlikely that this was a conscious didactic choice, it is evidence of the kind of analogical thinking we are concerned with in this chapter. The *ao* → *po* shell is, within Gell's *oeuvre*, a protention of the agent → patient relation.